BRITISH WATERCOLOURS

D1223696

*Tate Gallery Publications gratefully acknowledge
the support of Britoil in the production of this book*

ISBN 0 946590 52 4
Published by order of the Trustees 1986
Copyright © 1986 The Tate Gallery All rights reserved
Published by Tate Gallery Publications, Millbank, London SW1P 4RG
Printed in Great Britain by Westerham Press, Westerham, Kent

British Watercolours

by Judy Egerton

THE TATE GALLERY

Introduction

People who like watercolours tend to be very enthusiastic about them. Others seem never to get over a belief that watercolours are insubstantial things which do not deserve the serious attention merited by oil paintings. Perhaps the very word 'watercolour' is partly to blame for this, for it may convey, like the phrase 'watering-down', a sense of dilution and, by implication, of loss of strength; or it may be a legacy of the fact that artists who painted only in watercolour were ineligible for membership of the Royal Academy for many decades after its foundation in 1768.

To many people, the wish to paint in watercolour seems less glamorous, perhaps even less professional, than the urge to paint in oil; while the oil painter is romantically imagined striding abstractedly before an easel in an attic studio, the watercolourist is envisaged as a placid creature sitting in a meadow on a camp-stool, with a jam-jar of water and a neat black japanned tin box of prepared colours at his side. When Charles Ryder in *Brideshead Revisited* breaks the news to his father that he intends to become a painter, his father remarks 'I suppose you intend to do the thing thoroughly and use oil paint?'

The fact that watercolour painting in Britain has attracted so many amateurs over nearly three centuries has perhaps weakened critical respect for the art. 'Pont' of *Punch* singled out 'The Gift for Watercolours' as as much part of the British character as 'Absence of the Gift of Conversation' and 'Strong Tendency to become Doggy'; he portrayed the popular idea of the watercolourist as a maiden lady abroad, imperturbably recording the picturesque elements in what in fact looks like a rather *louche* district (fig.1). But it is no more rational to rate oil paintings as a higher branch of art than watercolour than it is to contend that rhyme is better than blank verse. The truth is, of course, that watercolourist and oil painters alike will only merit attention if the artist at work in either medium is blessed with expressive powers and some degree of originality.

This book illustrates watercolours in the Historic British Collection of the Tate Gallery – that is, watercolours by artists born before 1860 – not those in its Modern Collection, which deserve another book in this series. The potential of watercolour is beautifully summed up by Leslie Worth, one of the foremost watercolourists of our own day; his remarks are equally apt to watercolours painted in the past or today. Watercolour painting, he points out, is essentially a small-scale art form (the largest example in this book is J. R. Cozens's 'Lake Albano and Castel Gandolfo', 19¼ × 26¾ inches (plate 5): the smallest is J. M. W.

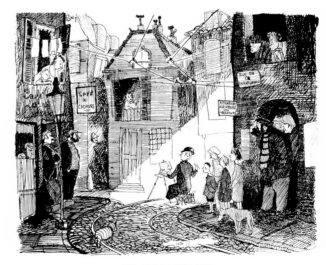

THE BRITISH CHARACTER.
THE GIFT FOR WATER-COLOURS.

Turner's 'Edinburgh Castle: March of the Highlanders' (plate 11), which is $3\frac{3}{8} \times 5\frac{1}{2}$ inches), but it is capable of rich and personal expression. As Worth puts it, 'Watercolours call for clear thinking and spontaneity of action, for exploration of the balance between broad masses of colour and linear patterns, and the contrasting of limpid washes of colour and sharp, active brushstrokes'.[1]

It is true that watercolour painting attracted (and continues to attract) many amateurs; indeed many of the professionals – Girtin, Cotman, Cox and de Wint among those represented in this book – supplemented their earnings from selling their work by giving lessons in drawing and painting to amateurs. Cox's *Treatise on Landscape Painting*, published in 1813, offering instruction 'from the 'first Rudiments, to the Finished Picture', was only one of innumerable manuals on watercolour painting. But any idea that the technique of watercolour painting is easily mastered must be discarded at once. Here is Leslie Worth, professional watercolourist and teacher, pointing out some of the difficulties: 'Anyone who paints with watercolours soon realizes that the medium has a life of its own, which can be exploited but rarely completely subdued. The washes are governed by the force of gravity and the colour will tend to run down the paper, especially if you are working on a tilted board; wet areas will 'bleed' into one another; and furthermore, the colour will dry out rapidly or not at all, depending on the humidity of the atmosphere. Every watercolourist must learn to anticipate the colour values in advance and make allowance for the loss of tone when the water evaporates'.

To see how the great watercolourists have triumphed over such problems, we should first understand how watercolour paint is made, and how paint and paper react to each other. Edward Norgate, writing about 1630, when artists had to go to apothecaries' shops to buy pigments which they then ground themselves, described the process of preparing watercolour paint in his day:

> Your colour being dry, reserve it in cleane papers and boxes for your use, and when you will fall to worke take as much as will lie in a mussel shell . . . and with a little gum water temper it with your finger till it come to a fitting consistency or stiffness, observing that your proporcon of Gum Arabique must be soe as neither to make the colour shiny which it will doe if it be too much gumd, nor when dry in the shell it will come off with a touch of your finger, which is a signe that it is gumd too little . . . For you must endeavour to make all your colours lie even and fast, without peeling or cracking, and this is done by adding a little white Sugar Candy in fine powder and with a few dropps of faire water temper the Colour till it bee thoroughly mixt and dissolved, and then it will be smooth and even.[2]

Norgate was writing at a time when painting in watercolours (or 'limning') was limited to their use in concentrated form, to colour portrait miniatures or illuminate books of devotion, rolls of heraldry or books of herbals. But from about 1700, watercolour began to be used to colour landscape; from about 1750 it was used for a wide variety of subjects, and by 1800 painting in watercolour had assumed the status of a separate branch of art. Demand created supply; from the middle of the eighteenth century, artists' colourmen sold prepared colours in cakes or ceramic pans, and offered selections of colours in boxes or tins. In 1801 the firm of Ackermann advertised 'A Neat Mahogany Box, with Six Cakes', at six shillings. Later the Royal Society of Arts offered a medal for a shilling watercolour paintbox. It was won by J. Rogers in 1853, and presented to him by the Prince Consort; within twenty years eleven million of them had been sold.[3]

Voices of today perhaps tell more effectively about materials than voices from the past. If Norgate's account of about 1630, with its references to 'dropps of faire water', now sounds quaint, it can usefully be supplemented by a leaflet published by a present-day Covent Garden firm of

1 *Working with Watercolour*, 1980, p.2

2 from *Miniatura, or the Art of Limning*, quoted in Martin Hardie, *Water-Colour Painting in Britain*, 1, 1966, p.11
3 Hardie, *op. cit.*, p.24

colourmen.[4] Under the heading 'How to make your own water colours' it gives instructions which hardly deviate from Norgate's but which explain the purpose of the various ingredients more simply: 'You will need: Gum arabic, distilled water, sugarine or honey, glycerine, ox gall and pigments'. Gum arabic is essential since particles of pigment and water by themselves will not stick to paper; it is readily soluble in water, and should be dissolved, this firm suggests, in seven times its quantity of distilled water (in Norgate's day, the quantity of water would have been very much less). Norgate's comments on the amount of gum needed are still relevant: too much gum will make the colour shiny, while too little will make the paint flake or 'come off with a touch of your finger'. The addition of glycerine and sugar (or honey, as Norgate recommended) stops the paint from drying solid; a few drops of ox gall can be used when painting to break surface tension. As the pigments are ground in the watery solution, the water will evaporate, and the resulting amalgam will be sleek and ductile (or 'smooth and even', in Norgate's phrase). From the beaker or bottle which the watercolourist will always have by his side, more water is added as the artist works, to produce spreadable colours of varying degrees of depth. Water is thus used twice: to mix pigments and to dilute the colours; but as Leslie Worth points out, the watercolourist has to anticipate the tones which will result when the water has evaporated. Watercolours do indeed call for quick thinking; and mistakes cannot be obliterated, as mistakes in oil painting can be, by superimposing more paint.

The essence of pure watercolour painting lies in the fact that its colours are transparent; they sink into the paper but never quite hide its own colour. The same strength of colour will thus show to different effect on white, buff or blue paper (or paper of any other colour). It will also produce different effects on different textures of paper. A brushful of watercolour moved across a rough paper will leave dark tints in its hollows and tiny points of light in its prominences; plate 17 shows the sort of textural effect David Cox liked to produce by working on rough paper.

The colour of paper itself can serve as a 'colour' if it is 'left', i.e. left unpainted. The white in Girtin's celebrated 'White House at Chelsea' (plate 9) is the effect of left paper, not white paint. Similar effects can be obtained by lifting colour from certain areas with a clean brush (breadcrumbs can also be used). Some watercolourists, wanting more body in their work, choose to mix some or all of their colours with opaque white, so that the colour of their paper will no longer show through; the result is known as 'body-colour' or gouache. Frederick Walker's 'The Housewife' (plate 30) is largely painted in gouache, that is, watercolour made opaque; Samuel Palmer's 'A Dream in the Apennine' (plate 27) is an example of gouache added to some areas of a work which is otherwise largely painted in pure watercolour. Joshua Cristall's 'Beach Scene at Hastings' has been chosen for the cover of this book not only because it is a strong image but also because it is purely watercolour.

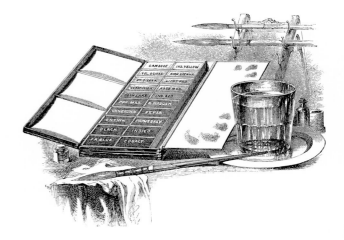

The Watercolourist's paraphernalia, from George Bernard, *The Theory and Practice of Landscape Painting in Water-Colours*, London, 1858

4 L. Cornelissen & Son, *The Presentation of Watercolours, Tempera, Oil Paints and Pastels*, n.d.

There is no subject in art which cannot be treated in watercolour, though it must be admitted that oil is probably a better vehicle for portraits of monarchs, headmasters and presidents of the Board of Trade, and for the ponderousness of most history paintings. But the British watercolourists' chief subject-matter has always been landscape. Watercolours first became popular in Britain as records of topography, or the portraiture of particular places, such as the drawings Francis Place began to make towards the end of the seventeenth century. His contemporary George Vertue records that Place 'travelld thro many parts of England Wales. into Ireland drew views of many places very well a great lover of fishing',[5] which sums up his career and the early watercolourists' fairly relaxed attitude towards their work. There was an increasing demand throughout the eighteenth century for 'views' which could be engraved and thus widen many a gentleman's knowledge of his own and other countries: so there were produced views of Gothic architecture and modern towns, ancient palaces and contemporary 'gentlemen's seats', views of the caverns of Derbyshire or the lakes of Cumbria, views in Scotland and Wales and in such distant countries as China, India Asia Minor or the South Seas.

Fuseli's dismissal of topography as 'the tame delineation of a given spot' must be one of the most frequently-quoted judgements in the history of British art; since topographical subjects inspired so many watercolourists, there is hardly a book on watercolour painting which does not quote it. Yet it is clear from Fuseli's context – a lecture given to Royal Academy students – that he was thinking of topography in oil painting rather than watercolour: 'The landscape of Titian, of Mola, of Salvator, of the Poussins, Claude, Elsheimer and Wilson, spurns all relation with this kind of map-work. To them, nature disclosed her bosom in the varied light of rising, meridian, setting suns; in twilight, night and dawn.'[6]

Many watercolourists preferred to paint generalized rather than specific landscapes. Alexander Cozens and Thomas Gainsborough, in different ways, helped to liberate landscape from 'map-work' by rearranging the ingredients of landscape as they chose. Alexander Cozens encouraged his students to get ideas for landscapes from random images or 'blots'; Gainsborough liked to compose ideas for landscape on a small folding table, on which he would arrange 'cork or coal for his foregrounds; make middle grounds of sand or clay, bushes of moss and lichens; and set up distant woods of broccoli'. The Rev. William Gilpin, an influential writer of treatises on 'the picturesque', encouraged artists to work 'from the *general face of the country*, not from any particular scene'. Military topography, which is how Paul Sandby started his career, demanded exactitude; but most watercolourists who painted views used some artistic licence, as Thomas Hearne does in his view of Edinburgh (plate 2), or J. M. W. Turner in his view of Edinburgh Castle (plate 11). Turner was to give the word 'picturesque' fuller meaning by combining, as in his *Picturesque Views in England and Wales*, the essential features of a place with his own perception of its individual character; his view of Aldeburgh in the Tate's collection, painted for *Picturesque Views in England and Wales*, is a good example. His vision of 'Luxembourg' (plate 12), painted at twilight, can certainly not be called 'map-work'.

The greatest watercolourists are those who are able to respond not just to landscape, whether specific or ideal, but to atmosphere. British weather has a lot to account for, much of it on the plus rather than the minus side. Its vagaries compared with, say, the predictably steady sunlight of Italy or the black and white of the long Scandinavian winter, stimulated British artists to try to capture its constantly changing effects. For this, watercolour proved a perfect medium. John Sell Cotman's sight of Mousehold Heath 'through a heavy hail-storm' made him exclaim 'Oh! rare and beautiful Norfolk!', and his letters home from Normandy, where the weather is scarcely different from that in England, sound the authentic voice of the romantic watercolourist's reponse to transient atmospheric effects:

5 *Vertue Note books II*, Walpole Society, xx, 1931–2, p.35

6 quoted in Eudo C. Mason. *The Mind of Henry Fuseli*, 1951, p.285

he described his impressions on Saturday 27th 1820, when he was on the road from Domfront to Mortain through 'beautiful and varied country', as 'everything a Painter could wish for, & the day from being very rainy, cleared up & turned out an artist's day, fine clouds, the shadows of which gave light and spirit to everything, & change upon change took place like magic – from light tones to the darkest purples'.[7] He saw Mont St. Michel in all weathers, including 'torrents, thunder & lightning & hail', as John Robert Cozens saw Padua (plate 6).

'Pictures in water-colours are a very important branch of English painting' wrote Dr Gustav Waagen in 1838 during a visit to English collections and exhibitions.[8] The English, who like to think of themselves as a diffident race, rarely make such massively simple pronouncements. Dr Waagen, Director of the Berlin Royal Gallery, continued 'I had before no idea of the depth, force, richness and clearness of colour, which is here attained in this mode of painting, and there is in these pictures such a peculiar charm, that I find the high favour which they enjoy extremely natural'. He was writing in the watercolourists' heyday. The Society of Painters in Watercolours, formed in 1804, held regular exhibitions; many of the works sent to these exhibitions sought to vie with the size and depth of colour of oil paintings. One critic was to complain in 1830 that 'Every year screws colouring up to a higher scale according to Exhibition pitch'. Samuel Palmer's 'A Dream in the Apenine' (plate 27) is an example of the fully worked up and highly finished work which tended to dominate Victorian watercolour exhibitions. But throughout the centuries, watercolourists have continued to paint watercolours which range from the sketchiest of impressions to elaborately finished compositions. Peter Greenham notes that 'there are watercolours which flow at once, and that's that, and there are those which have to be cultivated like gardens'.[9] Girtin's 'White House at Chelsea' (plate 9) is perhaps the supreme example of 'watercolours which flow at once, and that's that', where 'flowing' means fully assured and harmonious rather than necessarily rapid work. Frederick Walker's 'The Housewife' (plate 30) is an example of the sort of work which has to be cultivated, like a garden, yet which retains its freshness.

Some watercolourists make considerable use of pencil or pen and ink for preliminary work; others work entirely with the brush. Some watercolourists use only that medium (Girtin is believed to have tried oils only once). Others work happily in either medium (J. M. W. Turner is the greatest example). Some work occasionally in oils, and succeed in producing work which is equally fresh in either medium (David Cox's 'Rhyl Sands', one version of which is in the Tate,[10] is a good example of an oil painting which is treated as effectively as a watercolour). Some oil painters, like Sir Joshua Reynolds, never work in watercolour. For artists who use both mediums, the choice is probably governed by practicalities as well as by moods. Peter Greenham suggests that 'Comfort has something to do with it, I suppose: carrying a little box and a sketchbook rather than heavy equipment of tubes, canvas and easel', especially when the artist hopes to capture 'quick effects, like sunsets, or chickens fluffing'.

The stuff of the two materials evokes different sensuous responses in different artists; some love the smell of oil paint, while Albert Goodwin described it as 'a horrid medium, after the purity of clean-smelling watercolour'. Nowadays artists may choose to paint in new materials, for instance in acrylic on photographic paper, or in enamel on steel. But new materials do not drive out traditional ones. In a country where the art of painting in watercolours has blossomed over three centuries, there can be little doubt that it will long continue to do so.

7 ed. H. Isherwood Kay, 'John Sell Cotman's Letters from Normandy', *Walpole Society*. xv, 1926–7, p.115
8 *Works of Art and Artists in England*, 1838, pp.152–3
9 in correspondence

10 'Rhyl Sands', no. T04130 in the Tate's collection, is one of three oil versions of the subject (the others are in Birmingham and Manchester City Art Galleries); Cox's watercolour version is in the Victoria and Albert Museum

Thirty-two watercolours are illustrated in this book, arranged in chronological order according to their artists' dates of birth; this arrangement and the notes on the plates will, it is hoped, offer a general survey of watercolour painting in Britain during the eighteenth and nineteenth centuries. But since all the illustrations are drawn from the Tate's own collection, and since that collection is a relatively small one, some gaps are inevitable. The Tate has no major work in watercolour by Constable, Thomas Sandby, Towne, Dayes, Rooker, Flaxman, Prout or William Callow; it has nothing on paper at all, even in pencil, by Lely, Barlow, Hogarth, Samuel Scott, Taverner, John Inigo Richards, Ibbetson, Wright of Derby, Francia, the Daniells (William, Thomas or Samuel) or Danby. Two artists mentioned in the Introduction, Francis Place and William Gilpin, are not in fact represented at the Tate; and only in the last five years have single examples been acquired of the work in watercolour of Thomas Jones, Bonington and Linnell, all of whom are well represented at the Tate in oils.

Two watercolours were included in Sir Henry Tate's founding gift to the Tate Gallery; and since its opening in 1897 it has never been doubted, by the Tate's Trustees, curators or benefactors that watercolours, drawings and prints should play an important role in enhancing the Gallery's principal collection, which is of oil paintings.

There are now some 800 watercolours and drawings in the Tate's Historic British Collection, not counting 483 small studies by George Jones, mostly figure studies in pen and ink. Of the 800, about 200 are watercolours and drawings by Millais, Rossetti, Ford Madox Brown and Burne-Jones, who are not represented in this book (Leslie Parris's *The Pre-Raphaelites*, in the same series, illustrates the work of the first three).

For the first sixty-five years of this century, the Tate's collection of works on paper grew somewhat hapazardly. There were, providentially, some gifts and bequests of major importance, such as Mrs Ada Montefiore's bequest in 1928 of Girtin's 'White House at Chelsea' (plate 9), often acclaimed as the supreme example of the British water-colourist's art; John Robert Cozens's 'Lake Albano and Castel Gandolfo' (plate 5) was presented the same year. Gifts and bequests of several large groups of watercolours account for some disproportionately large representations, for instance of works by Lear, Muller and Brabazon. Some purchases were made, especially of studies and sketches for finished paintings in the collection. Otherwise, apart from the acquisition of works by William Blake (who has long been a special feature at the Tate, and is represented by over sixty watercolours), few deliberate attempts were made to represent the British watercolour tradition in general, until in 1967 that enlightened body the National Art-Collections Fund, which had in the past singled out the Tate for important single bequests, offered the Tate first choice from the bequest of Herbert Powell collection of watercolours. The sixty-one works chosen, added to earlier acquisitions, made it possible to present regularly changing exhibitions of watercolours at the Tate.

When the Clore Gallery for the Turner Collection opens in 1987, it is planned that the general collection of Historic British works on paper will be made available to the public in its new Study Room, as well as changing selections being displayed. The vast numbers of works by Turner which will dominate the collection make it more urgent that watercolourists, draughtsmen and printmakers among Turner's predecessors, contemporaries and followers should be adequately represented, both in their own right and to give perspective to the Turner Collection.

The collections of British works on paper in the British Museum and the Victoria and Albert Museum will always be larger and richer than those of the Tate. There is no intention to vie with those institutions. Instead we aim, more modestly yet with an enthusiasm spurred on by the advent of the full riches of the Turner Bequest, to continue to enhance our collection with discriminating purchases and to present regularly-changing exhibitions of watercolours and prints, and to alert both potential benefactors and members of the general public to the Tate's increasing potential as a centre for the enjoyment and study of works on paper.

Further Reading

Leslie Worth, *Working with Watercolour*, 1980

Iolo A. Williams, *Early English Watercolours*, 1951

Martin Hardie, *Water-Colour Painting in Britain*, 3 vols, 1966–8

Graham Reynolds, *A Concise History of Watercolours*, 1971

Andrew Wilton, *British Watercolours 1750–1850*, 1977

Michael Clarke, *The Tempting Prospect, A Social History of English
 Watercolours*, 1981

The dimensions are given in inches followed by millimetres in brackets: height precedes width

COVER

JOSHUA CRISTALL 1767–1847
*Beach Scene at Hastings c.*1808
Watercolour 7³⁄₁₆ × 11¹³⁄₁₆ (183 × 300)
Purchased 1974 [T 01851]

This has all the appearance of a sketch made on the spot, on two pages from a sketchbook joined together; but a small puzzle is presented by the fact that although Cristall has dated it '1807', both pages are clearly watermarked '1808'. Cristall is known to have gone to Hastings in 1807, the visit having been prescribed for him by his doctor, as Farington reports, to overcome 'a state of despondence . . . owing to want of success (encouragement) in consequence several Artists put down their names for 5 guineas each to make up a sum or him'. Possibly the drawing was made from recollection the following year. Farington adds that Cristall's drawings of Hastings were so much admired that 'a Host of Artists are preparing to go to Hastings'. Cristall's large and fully worked up watercolour 'The Fish Market on the Beach, Hastings' (30 × 41½ in) is in the Victoria and Albert Museum; by contrast, the Tate watercolour is a free sketch.

PAUL SANDBY 1730–1809
1 *The Cemetery Gate of St. Augustine's Monastery, Canterbury*
 dated 1782
 Watercolour over pencil, 12³⁄₄ × 20 (342 × 508)
 Presented by William Sandby 1901 [N 01856]

Paul Sandby trained as a military topographer in the Ordnance Board's drawing-office. He painted in oil as well as in watercolour and gouache. He was a founder-member of the Society of Artists in 1760 and the Royal Academy in 1768; his professional standing helped to give status to watercolourists in general. Here he depicts contemporary life bustling outside an ancient monastery, by 1782 long decayed and used as a public-house.

 Francis Cotes's portrait of Paul Sandby at work is in the Tate, and is almost always on view. Sandby sits at an open window, a pencil in his right hand, his paper resting on a book balanced on his knee, portrayed in one of the split seconds in which the habitual sketcher from life returns his eyes from his paper to his subject.

 Paul Sandby was a constant experimenter with materials, and managed to turn even a burnt breakfast brioche to advantage: scraping off the charred edges, he mixed the scrapings with gumwater and was delighted to report that he had thereby produced an excellent warm black colour'. He also experimented (like some other watercolourists) with adding alcohol to the water in his paint so that it would evaporate faster; Martin Hardie records that 'Sandby constantly used gin'.

THOMAS HEARNE 1744–1817
2 *Edinburgh from Arthur's Seat* dated 1778
 Pen and ink and watercolour, with some gouache, 12 × 19⁷⁄₈
 (305 × 505)
 Presented by Frederick J. Nettlefold 1947 [N 05792]

This view of Edinburgh is one of Hearne's best works. Finely composed as well as factually informative, it represents the eighteenth century approach to topography at its best. A pen and wash study for this subject (in the collection of the Yale Center for British art) was probably made on the spot in September 1778, during Hearne's tour of Scotland with Sir George Beaumont. The finished watercolour was probably worked up after Hearne's return to London. He has painted the view with some artistic licence, depicting the hills behind the city as higher and more rugged than in the sketch.

Hearne's colouring is always restrained, often limited to blues and greens over grey washes; much of his work is in grey monochrome over a coffee-coloured wash. Hearne had trained as an engraver; much of his own work was engraved, most notably the fifty-two illustrations for *The Antiquities of Great Britain*, whose plates are variously dated between 1778 and 1806. Martin Hardie suggests that Hearne's restrained colouring is largely due to the sympathetic desire of a man who had been an engraver himself to make the engraver's task as simple as possible. Hardie also draws attention to Hearne's lively skies – 'they are serene with touches of blue appearing through rifts of thin and ragged white cloud' – as a new feature in topographic art.

SAMUEL HIERONYMUS GRIMM 1733–1794
3 *Glacier of Simmenthal* dated 1774
 Pen and ink and watercolour, 11⅝ × 14⅝ (295 × 371)
 Purchased 1983 [T 03603]

Grimm made many watercolours of the glaciers of his native Switzerland, even after 1768, when he settled in England. In this example, as in almost all of them, his drawing is precise and his colour delicate. The image which results is 'curious', a favourite adjective of eighteenth century natural philosophers, rather than 'sublime' in the way later more romantic artists, above all Turner, were to portray the forces of nature.

Grimm's method of working was described by Gilbert White, who commissioned Grimm to illustrate his *Natural History of Selborne*: 'Mr Grimm . . . first of all sketches his scapes with a lead-pencil; then he pens them all over, as he calls it, with indian ink, rubbing out the superfluous pencil-strokes; then he gives a charming shading with a brush dipped in indian ink; and at last he throws a light tinge of water-colours over the whole'.

THOMAS JONES 1742–1803
4 *On the Road to Santa Maria de Monti near Naples* dated 1781
 Watercolour over pencil, 8⅜ × 11 (213 × 279)
 Purchased 1982 [T 03367]

Thomas Jones spent nearly eight years in Italy, from 1776–83, chiefly in Rome and Naples, passing his time 'very Agreeably rambling about and Making a Number of Views and Sketches of the Different scenes in this most picturesque Country'. Some-

times his friends among other English artists in Italy, such as Francis Towne and William Pars, accompanied him on excursions to famous sites; but as his *Memoirs* show, Jones found 'many picturesque Scenes of my Own discovery, entirely out of the common road of occasional Visitors, either Cavaliers or Artists'. Jones found endless pleasure in the scenery along the road to Santa Maria de Monti, just outside Naples, particularly in its groves of umbrella pines and walnut trees; he made at least twelve watercolours of different stretches of this road. While lodging in Naples itself, Jones discovered that its flat roofs offered good vantage points for views; he made many oil sketches on paper, many of them of roof top views. The Tate has four of his oils on paper, including one London scene painted after his return home.

JOHN ROBERT COZENS 1752–1797
5 *Lake of Albano and Castel Gandolfo* c.1783–8
 Watercolour, 19¼ × 26¾ (489 × 679)
 Presented by A. E. Anderson in memory of his brother Frank through the National Art-Collections Fund 1928 [N 04408]

Constable considered John Robert Cozens to be 'the greatest genius that ever touched landscape'; his work, Constable declared, was 'all poetry'. Apart from a few late English landscapes, almost all Cozens's watercolours were based on sketches made in Switzerland and Italy, as draughtsman first to the connoisseur Richard Payne Knight and then to William Beckford of Fonthill. In working up his sketches into finished watercolours, Cozens broke with the earlier topographical tradition of superimposing colour on work already virtually completed in monochrome; instead, he built up his masses with a minimum of preliminary pencilling but with countless minute touches of colour. His landscapes are charged with feelings of yearning and introspection, and were to have a profound influence on the next generation of watercolourists, particularly on Girtin and Turner.

Cozens painted at least nine versions of this subject, each with subtle differences in colouring and in mood. The Tate's version originally belonged to William Beckford; it was bought in his sale by Thomas Hearne (see no. 2).

JOHN ROBERT COZENS
6 *Padua*
 Watercolour, 10¼ × 14⅝ (260 × 371)
 Presented by the National Art-Collections Fund from the
 Herbert Powell Bequest 1967 [T 00983]

This is based on a study in one of Cozens's sketchbooks (now in
the Whitworth Art Gallery) inscribed 'Part of Padua from the
Walls – the mountains of ye Tirol', and dated 18 June (1782).
This watercolour also belonged to Beckford of Fonthill, and was
described in his sale as 'View of Padua in a storm, very spirited'.

THOMAS ROWLANDSON 1757–1827
7 *Landscape, Isle of Wight*
 Pen and ink and watercolour, 7⅞ × 10⅞ (200 × 276)
 Presented by the National Art-Collections Fund from the
 Herbert Powell Bequest 1967 [T 01014]

Rowland's brain teemed with ideas based on observations of
human behaviour, mostly of a more or less ludicrous kind; his
ideas quicken into life in his energetic cursive line. There is always
a lot going on in a Rowlandson watercolour, as in this scene in the
Isle of Wight, which Rowlandson visited in 1782; the full shapes of
the trees and hedges play their part in this rural idyll, as do the
hens, and the cottage's thatch is suggested by a few masterly
squiggles of the pen. Rowlandson's habitual colouring is curi-
ously delicate, softening the boisterousness or bawdiness of most of
his subject matter, and infusing his landscapes with unexpected
tenderness.

WILLIAM BLAKE 1757–1827
8 *Homer and the Ancient Poets*
 Pen and watercolour over pencil, 14⅝ × 20¾ (371 × 527)
 Purchased 1918 [N 03353]

Blake stands apart from most of the watercolourists of his day
because he rarely worked from nature or drew his subjects from
life, preferring instead to work by the light of his imagination.
'Homer and the Ancient Poets' is one of a series of one hundred
and twenty-two illustrations to Dante's *Divine Comedy* which John
Linnell commissioned, and on which Blake worked from 1824 to
his death in 1827; the series is now dispersed, the Tate owning

twenty of them. This illustration shows Dante and Virgil looking
into the abyss thick with cloud, and discovering the ancient poets
– Homer, Horace, Ovid and Lucan – by the light of a fire.

Even in his wildest imaginings, Blake's watercolour technique
and his colouring remain delicate and clear. Here the landscape
in which Dante (in red) and Virgil (in blue) find themselves is
formalised; it represents the grove of error, which prevented the
ancient poets from seeing the daughters of imagination. One
entire gallery at the Tate is devoted to the work of Blake and of
some of his followers.

THOMAS GIRTIN 1775–1802
9 *The White House at Chelsea* dated 1800
 Watercolour, 11¾ × 20¼ (298 × 514)
 Bequeathed by Mrs Ada Montefiore 1933 [N 04728]

Though Girtin died at the age of 27, he left enough work to estab-
lish his reputation as one of the greatest of all English water-
colourists. 'The White House at Chelsea', probably his most cele-
brated work, reveals all Girtin's finest qualities: his sure instinct
for composition, his exquisitely modulated sense of colour, his feel-
ing for breadth in landscape and, above all, his ability to suffuse a
landscape with the mood appropriate to a particular hour and
atmosphere.

Turner particularly admired 'The White House at Chelsea'
An anecdote often quoted is that 'A dealer went one day to
Turner, and, after looking round all his drawings in the room,
had the audacity to say, "I have a drawing out there, in my hack-
ney coach, finer than any of yours". Turner bit his lip, looked first
angry, then meditative. At length he broke silence: "Then I tell
you what it is. You have got Tom Girtin's 'White House at
Chelsea'".

Girtin preferred paper of a warm 'biscuit' colour to white. Here
Girtin produces the 'white' of the white house by leaving a small
irregular space of his paper unpainted. Within the shape of the
house, very light touches of pale yellow are applied, just enough
to suggest the texure of masonry; the space inside appears white
when opposed to the cold blue washes of the river.

THOMAS GIRTIN

10 *Bamburgh Castle, Northumberland* c.1797–9
 Watercolour with some gouache over pencil, 21⅝ × 17¾
 (550 × 450)
 Presented by A. E. Anderson in memory of his brother Frank
 through the National Art–Collections Fund 1928 [N 04409]

A good technical analysis of this work is given by Kasia Szeleynski of the Tate's Conservation Department, in the Tate exhibition catalogue *Completing the Picture*. She points out that here Girtin 'restricted his palette to a very few colours which allowed him to express fully his emotions and depict the potency of light and darkness . . . The painting started out as a very brief, impatient pencil drawing visible in the middle of his picture. The first layer of a lightly applied colour followed. The brush strokes appear to be perfectly spontaneous but the rich blots of colour are precisely placed. There follows a more detailed layer in darker, deeper tones of greens and blues applied with a smaller brush to emphasize the shadows and to sculpt the landscape. He also uses a few strokes of white opaque paint, not so much to bring out the highlights but more to portray details such as the seagulls. . .'

Lesser artists might have depicted the castle ruins in a conventional antiquarian manner. Girtin succeeds, without melodrama, in making a sublime image of them.

JOSEPH MALLORD WILLIAM TURNER 1775–1851

11 *Edinburgh Castle: March of the Highlanders* engraved 1836
 Watercolour, 3⅜ × 5½ (86 × 140)
 Bequeathed by R. H. Williamson 1938 [N 04953]

This is based on sketches which Turner made on the spot in August 1822, to record King George IV's visit to Edinburgh. The ceremonies of welcome were planned and co-ordinated by Sir Walter Scott, who observed that 'a tartan fit' came over the city during the royal visit. Turner made this watercolour vignette some years later for the title-page of Scott's *Provincial Antiquities and Picturesque Scenery of Scotland* (1819–26). It celebrates the royal procession to Calton Hill to lay the foundation stone of the National Monument. Edinburgh Castle looms in the background; the foreground is dominated by Highlanders marching to the pipes, with the tartan, the symbol of Scottish tradition, used for magnificent colour effects. One critic of the pageantry observed that despite much 'respect and admiration for the noble

and generous qualities which the Highland clans have so often exhibited, it was difficult to forget that they had always constituted a small and unimportant part of the Scottish population...'

JOSEPH MALLORD WILLIAM TURNER

12 *Luxembourg* ?1834
 Watercolour and gouache on blue paper, 5⅜ × 7⅛
 (137 × 187)
 Bequeathed by Beresford Rimington Heaton 1940
 [N 05237]

Turner began as a watercolourist, and though his public reputation was founded on oil paintings, he continued throughout his life to use watercolour, with unsurpassed inventiveness and virtuosity, both for sketches and finished works. He was an indefatigable traveller, with a lifelong habit of making rapid sketches in pencil, which he transformed, sometimes years later, into watercolours or oils.

This study was made on one of Turner's tours gathering material for a projected publication of his views of the 'Rivers of Europe' (only those of the Seine and the Loire were in fact published). Here he turns the blue of his paper to positive advantage, adding a crescent moon and a few wisps of pale yellow wash and producing a twilight effect in which the town of Luxembourg glimmers mysteriously above the winding river.

PAUL SANDBY MUNN 1773–1845

13 *Bedlam Furnace, Coalbrookdale* dated 1803
 Watercolour, 12¾ × 21⅝ (324 × 550)
 Purchased 1986 [T 04172]

Paul Sandby Munn, a godson and pupil of Paul Sandby, was a member of Girtin's Sketching Club, and was influenced by Girtin's style. Munn was a friend of John Sell Cotman, and his companion on several sketching tours. In 1802 they went on a tour of Wales, pausing on their route at Coalbrookdale in Shropshire, centre of the Industrial Revolution, where Abraham Darby first smelted iron using coke as a fuel in 1709. Inspired by Philip de Loutherbourg's spectacular oil painting 'A View of Coalbrookdale by Night', exhibited at the Royal Academy in 1801 (now in the Science Museum), both Munn and Cotman painted watercolours of the scene, worked up from sketches made on the spot. Munn's view, exhibited at the Royal Academy in 1803, is one of his most powerful works.

JOHN SELL COTMAN 1782–1842
14 *Norwich Market Place* 1806
 Watercolour, 16 × 25½ (406 × 648)
 Presented by F. E. Halsey 1967 [N 05636]

Cotman has a very individual way of drawing and painting, producing simplified but very satisfying shapes and patterns of colour: 'Draw sternly and true, *Leave out, but add nothing*', Cotman advised his son. Cotman is now acclaimed as one of the greatest of all the English watercolourists; yet his whole life was dogged by financial difficulties and lack of recognition. This view of Norwich market-place – another view of it is in the Abbott Hall Art Gallery, Kendal – exemplifies Martin Hardie's observation that where Cotman excels 'is in his definition of detail combined with largeness of pattern'.

CORNELIUS VARLEY 1781–1873
15 *Evening at Llanberis* dated 1805
 Watercolour, 7⅞ × 9⅜ (200 × 238)
 Purchased 1973 [T 01710]

This was painted on the third of Cornelius Varley's tours of Wales, in 1805. That year he wrote a long note on 'the gradual progress from a cloudless morning to universal rain' in the region of Snowdon. The simplicity and almost abstract quality of this painting give it a powerful and meditative feeling, but there can be little doubt that here, as always, Cornelius Varley is working from nature.

Cornelius Varley was the younger brother of John Varley, whose work is so far inadequately represented at the Tate.

CORNELIUS VARLEY
16 *Canonbury House, Islington* after 1804
 Watercolour, 8⅜ × 12⅜ (213 × 314)
 Purchased 1973 [T 01713]

Cornelius Varley was trained as a maker of scientific instruments; science remained his major interest throughout his long life. In an autobiographical document he wrote that his purpose in drawing and painting landscape was 'to observe and understand what I saw'. He was particularly interested in trying to portray and the movement of trees, but his response to landscape was by no means purely analytical. Here he is recording part of the expansion of building in London; the result is astonishingly direct and lively.

DAVID COX 1783–1859
17 *Still Life* c.1830
 Watercolour over black chalk, 6¾ × 8⅜ (172 × 222)
 Bequeathed by James Richardson Holliday 1927 [N 04307]

Cox's use of watercolour became increasingly robust and powerful. He liked to work rapidly, 'with a large brush charged as full as possible with very wet though rich colour', on coarse textured paper which allowed glints of light to vibrate through the brush-strokes, as they do here. Cox was an influential teacher; this vigorous still life may have helped to quicken his pupils' response to everyday objects. Some contemporaries considered Cox's manner to be 'rough'; to us he seems to anticipate Impressionism, particularly in the transient effects which he captures in landscape.

DAVID COX
18 *Near the Pont d'Arcole, Paris* painted in 1829
 Watercolour over pencil, 9⅝ × 14½ (244 × 368)
 Bequeathed by James Richardson Holliday 1927 [N 04302]

Cox is one of the most vigorous and powerful of English watercolourists. He visited Paris in 1829, but had the misfortune to sprain an ankle there. As his biographer Solly notes, Cox was 'not to be baffled in his intention of sketching the monuments of Paris; so, with his usual spirit . . . he used to drive out in a fiacre, or cab, every day, and making it stop when he came to an interesting subject that took his fancy, he painted away indefatigably for many weeks, seated in the cab, or occasionally in a chair near the Seine or in some other not overcrowded spot'.

SIR DAVID WILKIE 1785–1841
19 *Mrs Elizabeth Young in Eastern Costume* dated 1841
 Pencil and watercolour heightened with white, 19½ × 13¼
 (495 × 337)
 Bequeathed by Mrs Elizabeth Young 1900 [N 01727]

In 1840 Wilkie set out for the Holy Land by way of Constantinople. He wrote that 'My Object in the voyage was to see what has formed the scene of so many pictures – the scenes of so many subjects painted from Scripture, but which had never been seen by the painters who delineated them'. It was on his voyage home the next year that Wilkie died and was buried at sea, inspiring Turner's painting 'Peace – Burial at Sea' (in the Tate Gallery).

Elizabeth Young was the wife of the British Consul at Jerusa-

lem. Like some of the other English residents, she agreed to sit to Wilkie in native dress. Wilkie records in his journal that he worked on the portrait of Mrs Young on 25–26 March 1841. He died at sea just over two months later, on 1 June 1841.

JOHN FREDERICK LEWIS 1805–1876

20 *Chapel of the Burning Bush, Mount Sinai* dated 1843
Pencil and watercolour, 14½ × 19½ (368 × 495)
Presented by Lady Holroyd 1919 [N 03395]

Lewis spent thirteen years abroad without an interval, chiefly in Cairo, appearing to live, as his friend Thackeray wrote, 'like a languid Lotus-eater – a dreamy, hazy, lazy, tobaccofied life', but in reality producing innumerable sketches of the streets and encampments, churches, bazaars and harems, which were to provide the basis of his work for the rest of his life. His view of the interior of the 'Chapel of the Burning Bush' is a study, not a finished work, but it beautifully catches the dimly-lit mystical atmosphere of the chapel. From 1858 onwards, Lewis concentrated on oil painting, finding that he could see his oils for very much more than his watercolours. His work in both mediums became increasingly jewel-like in finish and microscopic in detail.

PETER DE WINT 1784–1849

21 *Bridge over a Branch of the Wytham, Lincolnshire*
Watercolour over traces of pencil, 16⅜ × 20⁵⁄₁₆ (417 × 516)
Bequeathed by John Henderson 1879 [N 03492]

De Wint was strongly influenced by Girtin's work. His own preference was for low-lying landscape, usually seen under noonday skies; the level countryside around Lincolnshire, where his wife came from, inspired some of his finest watercolours. De Wint habitually used warm, deep-toned colours. Rich browns give a prevailing note of mellowness to this scene, which is subtly animated by a suggestion of rustle in the grasses and ripples on the water, made by scraping out highlights with the palette knife while the colour was still wet.

De Wint rarely signed or dated his work, and his manner did not greatly change during his career. He chiefly painted in watercolour, but painted some landscapes in oil. He also painted some remarkable studies of plants in oil on paper, in which he uses oil with the same fluency and spontaneity as watercolour; 'Study of Burdock and Other Plants' in the Tate is a good example.

DAVID ROBERTS 1796–1864

22 *Ronda, Spain* dated 1834
Presented by the National Art-Collections Fund from the Herbert Powell Bequests 1967 [T 01011]

Roberts travelled in Spain in 1832–3, when few artists knew the country; David Wilkie declared in 1828 that Spain was still 'the wild unpoached game reserve of Europe'. Many of Roberts's views in Spain were engraved for the Jennings' *Landscape Annuals, The Tourist in Spain* and Roberts's own *Picturesque Sketches in Spain.* This view of Ronda conveys a vivid impression of the town's dramatic setting, perched on a rocky height which falls on three sides a sheer 400 feet; in Roberts's day the only approach by land was along a narrow track guarded by a Moorish castle.

Roberts's friend and biographer James Ballantine, wrote that Roberts 'seemed to have the faculty of photographing objects on his eye, for I have again and again been with him while he was sketching very elaborate structures or very extensive views, and he took in a large mass at one glance, not requiring to look again at that portion until he had it completed in his sketch. Other artists caught only small bits at a time and required to be renewing their glances continually'.

RICHARD PARKES BONINGTON 1802–1828

23 *Beach Scene on the French Coast*
Watercolour over pencil, 8⅜ × 13 (213 × 242)
Purchased 1984 [T 03857]

Bonington migrated with his parents from Nottingham to Calais when he was fifteen; later he studied in Paris and in Italy, making a few short visits to England before his death (of consumption) in his twenty-sixth year. Bonington painted equally brilliantly in watercolours and in oils, sometimes painting the same subject in watercolour and in oil: his oil version of this subject is at Woburn Abbey. All his work is distinguished by its clarity and crispness. Martin Hardie considers that his particular contribution to watercolour painting was 'a new luminosity and a lyric gift of colour'. Bonington's work was much copied, both in England and in France, where efforts to imitate his manner were known as 'le Boningtonisme'.

THOMAS SHOTTER BOYS 1803–1874

24 *The Seine and Palace of the Tuileries*
Watercolour, some highlights scratched out, $7\frac{7}{8} \times 11\frac{5}{8}$
(200 × 295)
Presented by the National Art-Collections Fund from the
Herbert Powell Bequest 1967 [T 00966]

Thomas Shotter Boys, a Londoner, trained as an engraver. In
1825, at the age of twenty-two, he went to Paris, where he met
Bonington, and took up watercolour painting on his advice.
Boys's style, though much influenced by Bonington's, retains its
own crisp and good-humoured individuality, based on keen pow-
ers of observation and a sure instinct for complementing architec-
tural drawing with lively details from contemporary life. Boys
later perfected the technique of chromolithography, displaying it
to brilliant effect in his publications *Picturesque Architecture in Paris,
Ghent, Antwerp, Rouen & c.* (1839) and *Original Views of London As It
Is* (1842).

GEORGE PRICE BOYCE 1826–1897

25 *Landscape: Wooton, Autumn* dated 1864–5
Bequeathed by Mrs Lawder-Eaton through the National
Art-Collections Fund 1940 [N 05250]

Boyce trained as an architect, but after three years' study (and
having private means) he gave up architecture for painting. His
eye for perspective is always sure, even in landscapes like this,
where the only 'architectural' subject-matter is the fence which
skirts a field and ascends a gentle slope towards a red brick build-
ing in the distance. Boyce rarely chooses a grand view and hardly
ever depicts a facade, preferring the more intimate and unasser-
tive subjects offered by barns and outbuildings and the side walls
of churches and abbeys, often glimpsed behind trees, and made
lively by the informal presence of ducks, pigs or birds. Boyce's
diaries are a source of information about members of the Pre-
Raphaelite elite circle such as Holman Hunt and Rossetti, but
his own attitude to his chosen subjects is free from the brooding
quality of his Pre-Raphaelite friends.

JOHN LINNELL 1792–1812

26 *Tatham's Garden, Alpha Road, at Evening* dated 1812
Watercolour, 4 × 4$\frac{7}{8}$ (102 × 125)
Purchased 1985 [T 04139]

Linnell was a member of the Water-Colour Society from 1810 to
1820, when he resigned to concentrate on landscape and portrait
painting in oils. Linnell was one of a group of young artists who,
around the turn of the century, liked to work direct from nature,
as he does here in a very direct way.

The 'Tatham' to which this garden belonged was Charles
Tatham, architect and friend of William Blake; 'Alpha Road'
(not an uncommon street name in London) appears to have been
in Bayswater, then on the outskirts of London, near where Linnell
himself lived at this period. Linnell later admired and befriended
Blake, commissioning his illustrations to Dante's *Divine Comedy*
(see no.8); Linnell also exerted considerable influence on Samuel
Palmer, who married his daughter Hannah.

SAMUEL PALMER 1805–1881

27 *A Dream in the Apennine* exhibited 1864
Watercolour and gouache, 26 × 40 (660 × 1016)
Bequeathed by Mrs H. F. Medlicott 1950 [N 05923]

This is a good example of the sombre and heavily worked-up
watercolours which Samuel Palmer made in later life. The draw-
ings which Palmer made during the years he spent at Shoreham
in Kent, from 1825 to 1835, often called his 'visionary years', are
technically much simpler. The Tate has good examples of Pal-
mer's visionary drawings which, like 'The Bright Cloud', were
made with pen and ink and sepia wash, and of his paintings in
tempera (watercolour paint mixed with egg) such as 'Coming
from Church'. Later Palmer's work, while continuing to reflect a
very personal vision of landscape, became technically more com-
plex, and arguably less satisfying. He exhibited this work in 1864
with a note which conveys something of what the 'Appennine'
landscape meant to him:' . . . ground which Virgil trod and
Claude invested with supernatural beauty'. Parts of it are painted
with several layers of paint, so thick in fact that in some places the
colour has flaked or cracked; other areas seem to be coated with a
concentrated solution of gum. It remains a powerful work,
charged with mystery and with reverence for the past.

EDWARD LEAR 1812–1888

28 *Trees in the Garden of the Villa San Firenze, Florence* dated 1861
Pen and ink and watercolour, 9 × 13⅞ (229 × 352)
Presented by the Earl of Northbrook 1910 [N 02799]

Edward Lear's life was a constant battle against financial diffi-
culties and poor health. He triumphed over them by his sense of
humour and his boundless appetite for work. Lear is of course
renowned for his nonsense verse, but the mainstay of his career
was landscape painting. He travelled continually from about
1837, in Europe, the East, India and Ceylon, making innumer-
able studies which he later worked up into finished watercolours
(and some oils). This view of cypresses in the garden of a villa in
Florence was probably made for his own record; he portrays
them with a combination of keen observation from nature and a
distinct sense of the quirkiness of their shapes.

WILLIAM HENRY HUNT 1790–1830

29 *Primroses and Bird's Nest* c.1830
Watercolour and gouache, 7¼ × 10¾ (184 × 273)
Bequeathed by Miss Moss 1920 [N 03564]

Hunt was a Londoner, the son of a tinplate worker. He suffered
from malformation of the bones in his legs and, according to an
uncle, 'was always a cripple, and as he was fit for nothing, they
made an artist out of him'. Hunt's early subjects were mainly
London and farmyard scenes, and genre pictures of street urchins
or young girls reading or sewing. From about 1830 he began to
paint still-lifes of fruit, flowers and bird's nests, and finding these
sold well, concentrated on them to such an extent that he was
nicknamed 'Birds' Nest Hunt'; as his biographer Stephens remar-
ked, Hunt could never resist 'the crackle of crisp bank-notes'.
Hunt developed a special technique for his still-lifes, either mixing
watercolour and gouache, as he does here, or preparing a white
ground and then painting in pure watercolour on it; both
methods produced brilliant effects. In December 1863, a few
weeks before his death, Hunt wrote to Linnell that he still worked
very hard at 'grapes and apples', but added 'I wish persons would
like the drawings as bits of colour instead of something nice to
eat'.

FREDERICK WALKER 1840–1875

30 *The Housewife* painted in 1871
Watercolour and gouache, 17 × 10 (178 × 254)
Bequeathed by R. H. Prance 1920 [N 03526]

Frederick Walker was chiefly a designer of black and white illus-
trations, though he also worked in watercolour, with Birket Fos-
ter's encouragement and in his manner, and in oils. He painted
this scene of a woman shelling peas in the summer of 1871, taking
the background from his friend Charles Collins's London house,
and commenting endearingly 'I meant her to be a little *creamy* sort
of woman'.

The amount of gouache which artists like Walker and Birket
Foster used for highlights in their works worried most of the pure
watercolourists; Albert Goodwin records one critic as saying that
it would be 'the ruin of watercolours'. In 'The Housewife' Walker
uses gouache throughout, but never oppressively: he uses it here,
for instance, to give highlights to the polish on the old chair,
brightness to the flowers in their terracotta pots and a watery
gleam to the tap on the barrel and the mouth of the drain-pipe.

ALBERT GOODWIN 1845–1932

31 *Ely Cathedral* dated 1908
Watercolour, 10 × 14¾ (254 × 375)
Presented by Miss Evelyn de Ponsonby McGhee
1908 [N 02299]

Goodwin was a very prolific artist; his grand-daughter recalled
that 'he seemed never to stop painting except to eat or bicycle or
walk'. Goodwin was greatly influenced by Turner's water-
colours, and particularly by Turner's sense of colour. Occasion-
ally Goodwin tried painting in oils, but greatly preferred water-
colour; his diary (privately published in 1934) records on one
occasion 'put away brushes and oil paint, for a finishing of what
is to me – a horrid material, after the purity of clean-smelling
watercolour'.

Goodwin was fond of twilight effects, and of cathedral subjects
with figures; as well as Ely, he painted the cathedrals of Salisbury,
Exeter and Canterbury, the latter with red-coated soldiers
marching past, perhaps on their way to the Boer War.

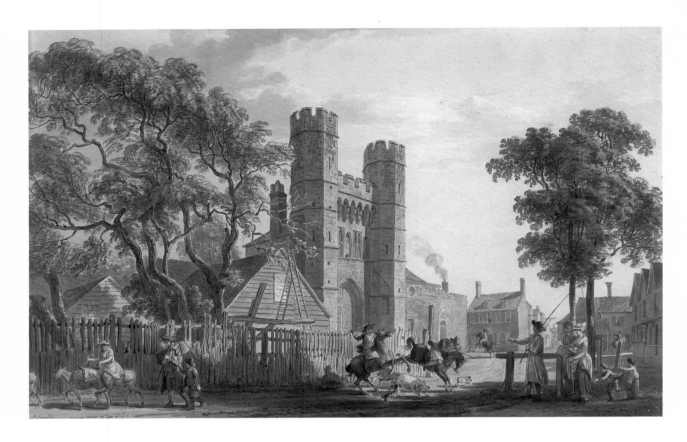

1 Paul Sandby
The Cemetery Gate of St. Augustine's Monastery,
Canterbury dated 1782
Watercolour over pencil, 12¾ × 20
(342 × 508)
[N 01856]

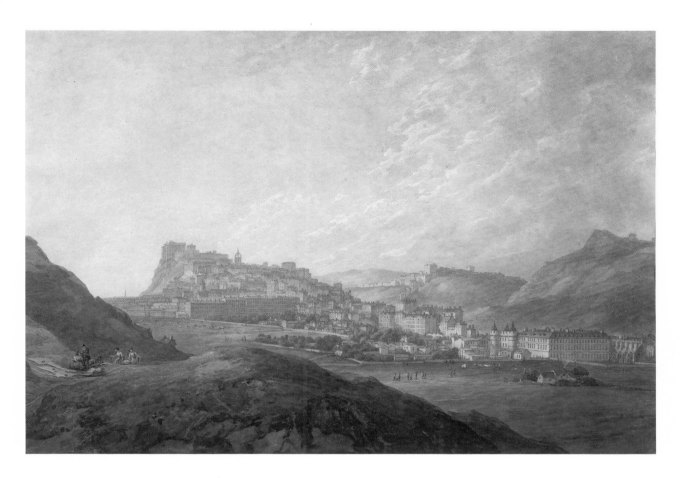

2 Thomas Hearne
Edinburgh from Arthur's Seat dated 1778
Pen and ink and watercolour, with some
gouache, 12 × 18⅞ (305 × 505)
[N 05792]

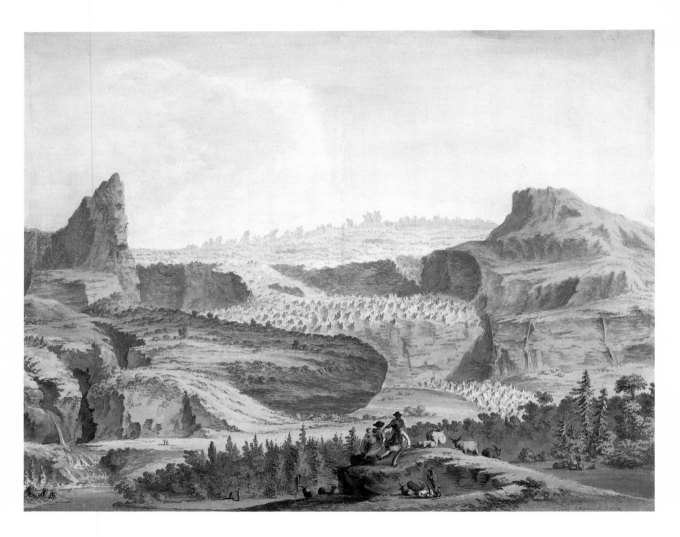

3 Samuel Hieronymus Grimm
 Glacier of Simmenthal dated 1774
 Pen and ink and watercolour, $11\frac{5}{8} \times 14\frac{5}{8}$
 (295×371)
 [T03603]

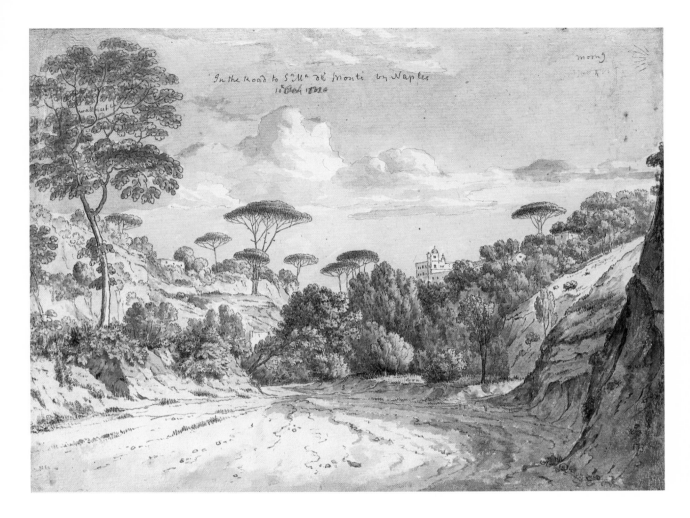

4 Thomas Jones
*On the Road to Santa Maria de Monti near
Naples* dated 1781
Watercolour over pencil, 8⅜ × 11
(213 × 279)
[T 03367]

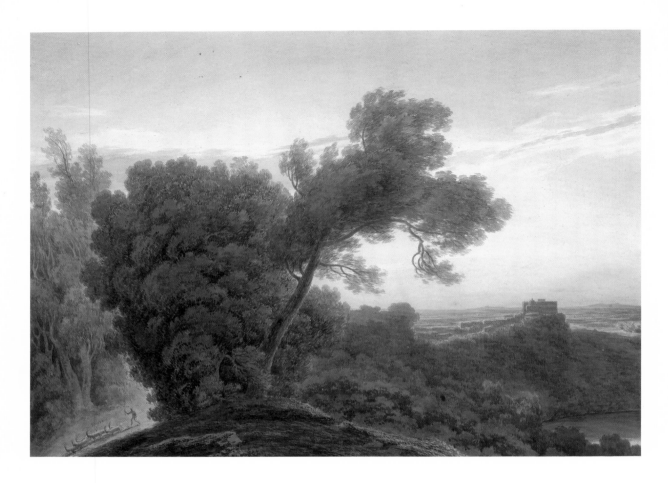

5 John Robert Cozens
 Lake of Albano and Castel Gandolfo *c.*1783–8
 Watercolour, 19¼ × 26¾ (489 × 679)
 [N 04408]

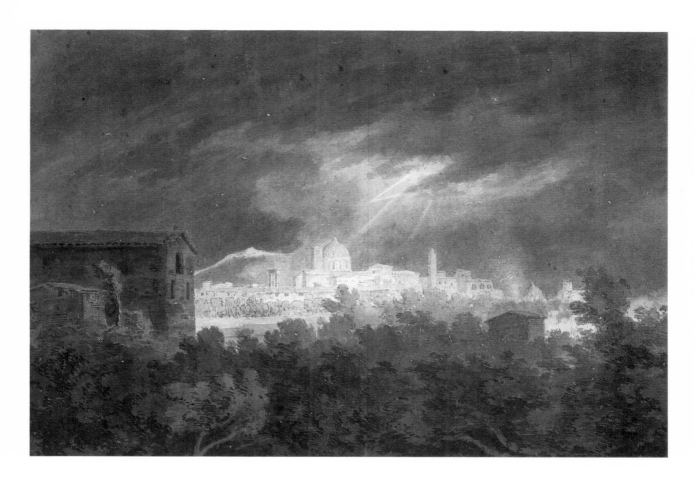

6 John Robert Cozens
 Padua
 Watercolour, 10¼ × 14⅝ (260 × 371)
 [T00983]

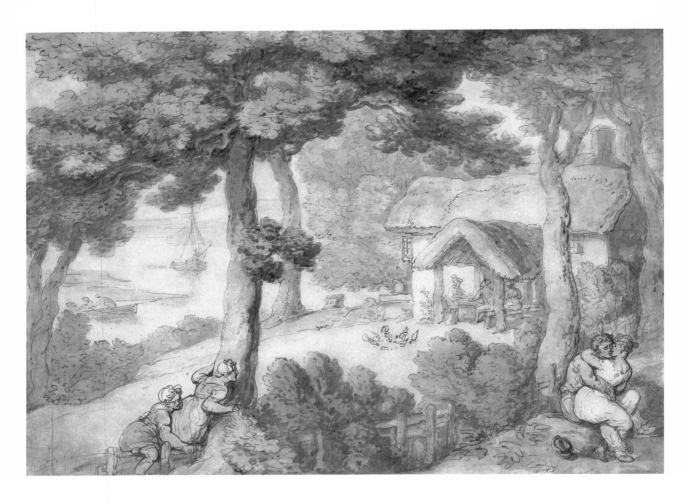

7 Thomas Rowlandson
Landscape, Isle of Wight
Pen and ink and watercolour, 7⅞ × 10⅞
(200 × 276)
[T01014]

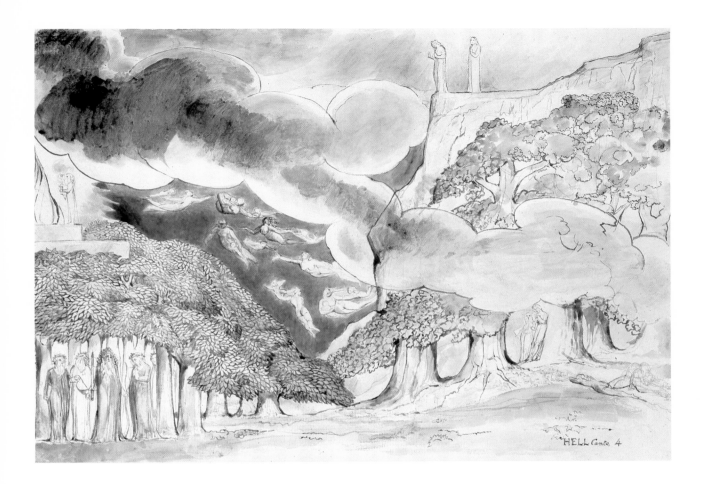

8 William Blake
Homer and the Ancient Poets
Pen and watercolour over pencil, 14⅜ × 20¾
(371 × 527)
[N 03353]

9 Thomas Girtin
 The White House at Chelsea dated 1800
 Watercolour, 11¾ × 20¼ (298 × 514)
 [N 04728]

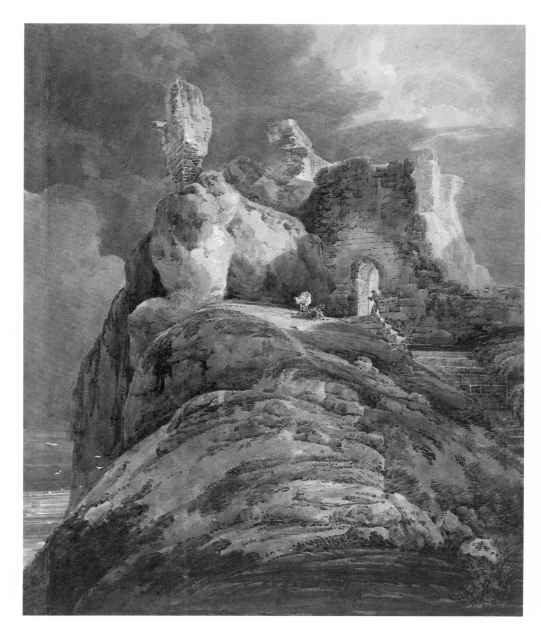

10 Thomas Girtin
Bamburgh Castle,
Northumberland 1797–9
Watercolour with some
gouache over pencil,
21⅝ × 17¾ (550 × 450)
[N 04409]

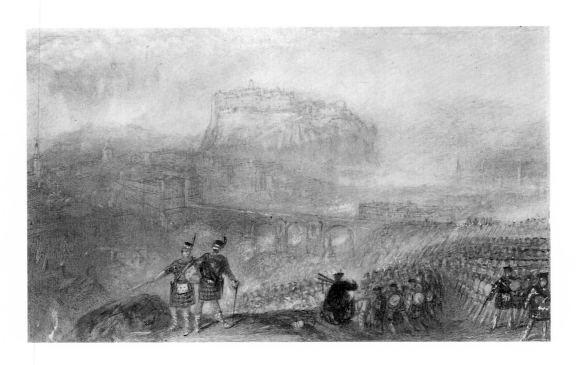

11 Joseph Mallord William Turner
Edinburgh Castle: March of the
Highlanders engraved 1836
Watercolour, $3\frac{3}{8} \times 5\frac{1}{2}$ (86 × 140)
[N 04953]

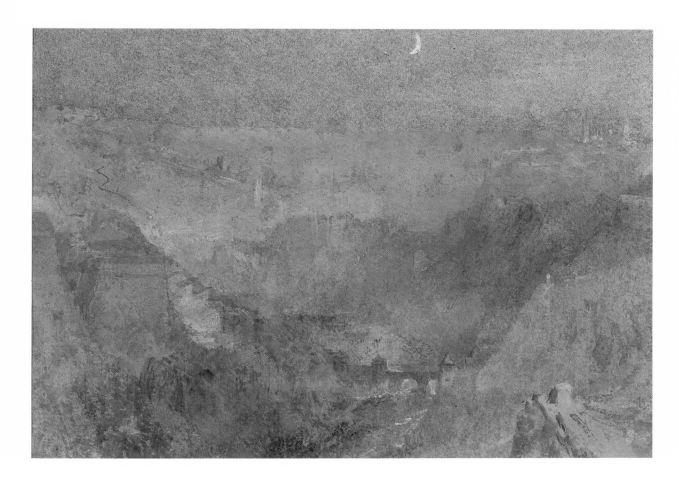

12 Joseph Mallord William Turner
 Luxembourg ?1834
 Watercolour and gouache on blue paper,
 5⅜ × 7⅛ (137 × 187)
 [N 05237]

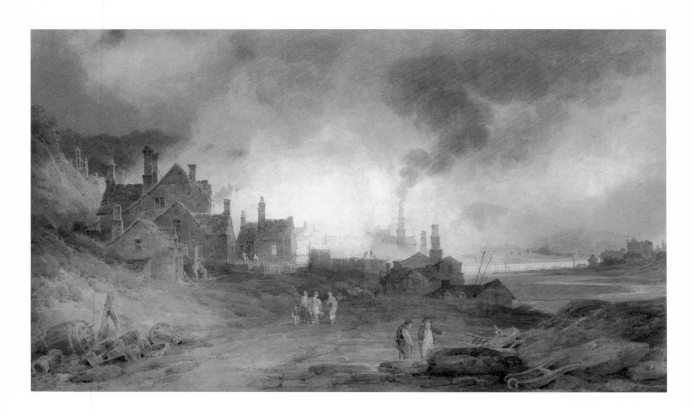

13 Paul Sandby Munn
 Bedlam Furnace, Coalbrookdale dated 1803
 Watercolour, 12³⁄₄ × 21⁵⁄₈ (324 × 550)
 [T04172]

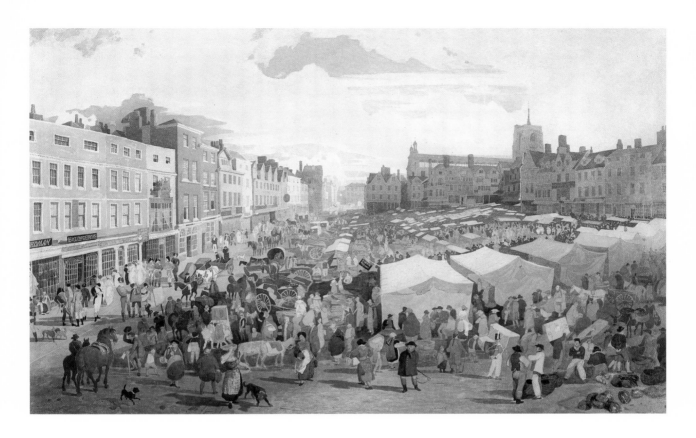

14 John Sell Cotman
Norwich Market Place c.1806
Watercolour, 16 × 25½ (406 × 648)
[N05636]

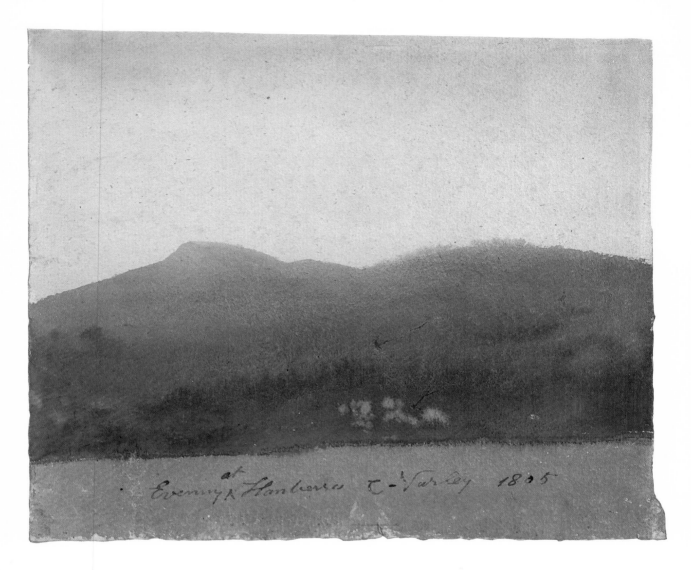

15 Cornelius Varley
Evening at Llanberis dated 1805
Watercolour, 7⅞ × 9⅜ (200 × 238)
[T01710]

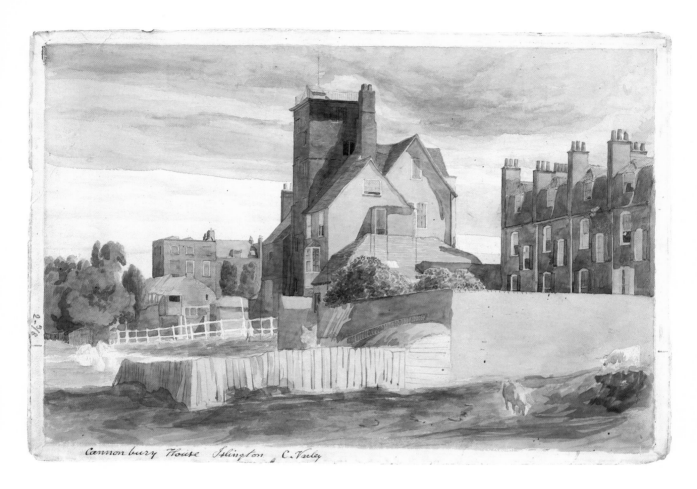

Cannonbury House Islington C. Varley

16 Cornelius Varley
Canonbury House, Islington after 1804
Watercolour, 8⅜ × 12⅜ (213 × 314)
[T01713]

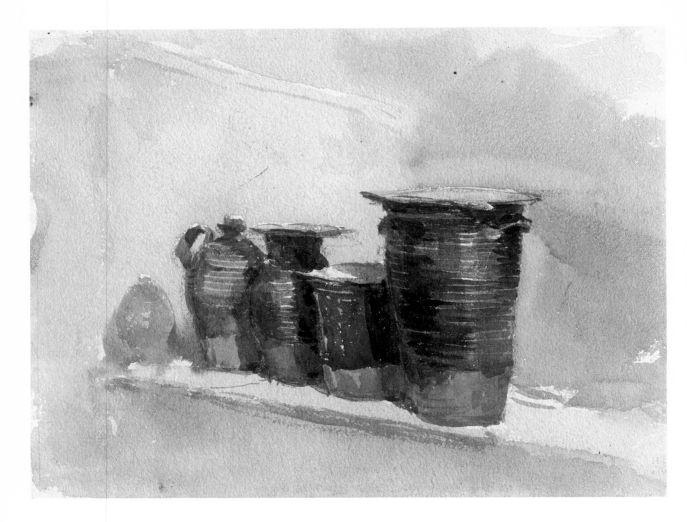

17 David Cox
Still Life c.1830
Watercolour over black chalk, 6¾ × 8¾
(172 × 222)
[N04307]

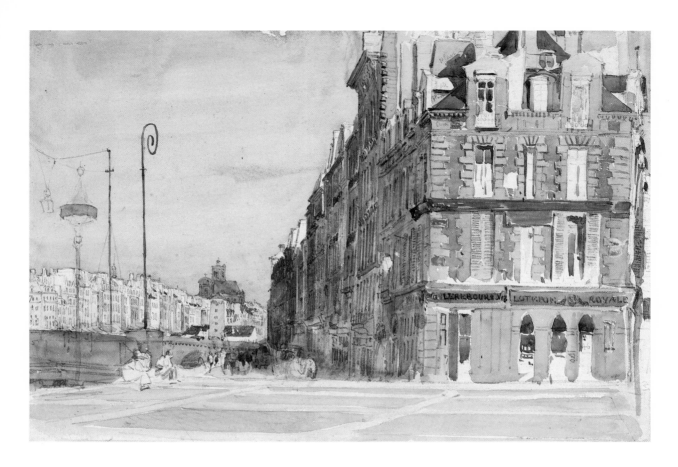

18 David Cox
Near the Pont d'Arcole, Paris painted in 1829
Watercolour over pencil, 9⅜ × 14½
(244 × 368)
[N 04302]

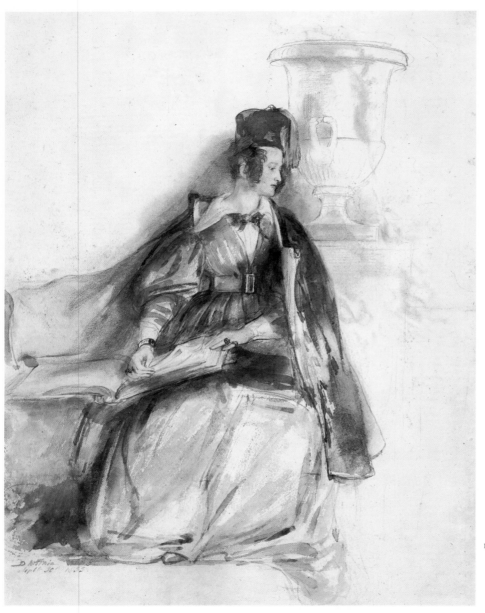

19 Sir David Wilkie
Mrs Elizabeth Young in Eastern Costume
dated 1841
Pencil and watercolour heightened
with white, 19½ × 13¼ (495 × 337)
[N01727]

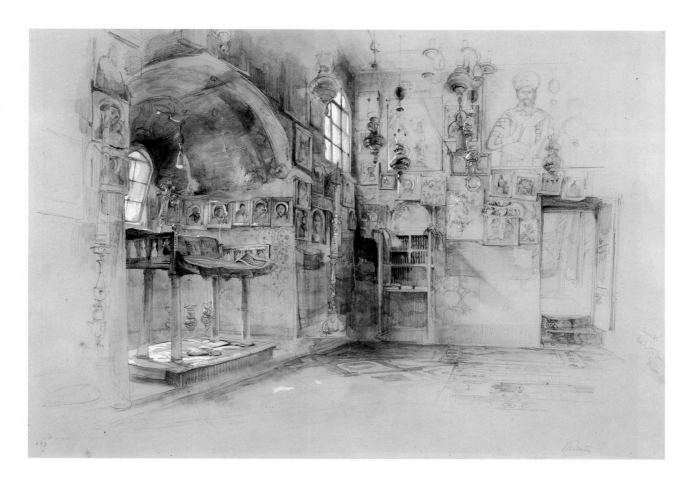

20 John Frederick Lewis
Chapel of the Burning Bush, Mount Sinai dated
1843
Pencil and watercolour, 14½ × 19½
(368 × 495)
[N 03395]

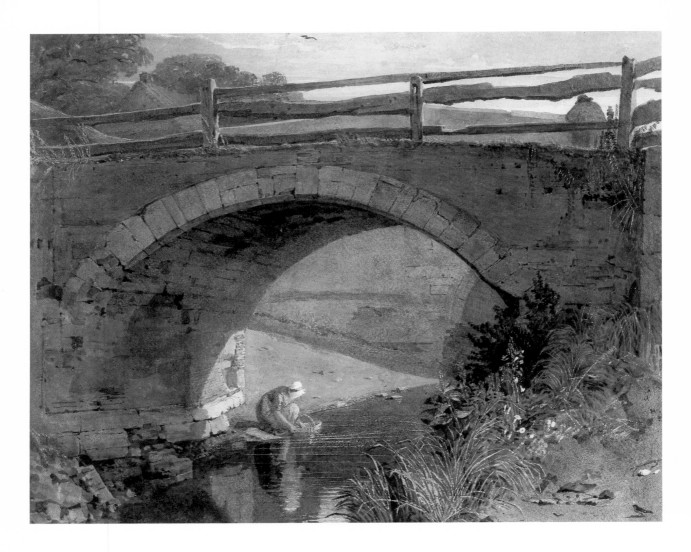

21 Peter de Wint
Bridge over a Branch of the Wytham, Lincolnshire
Watercolour over traces of pencil,
16⅜ × 20⁵⁄₁₆ (417 × 516)
[N 03492]

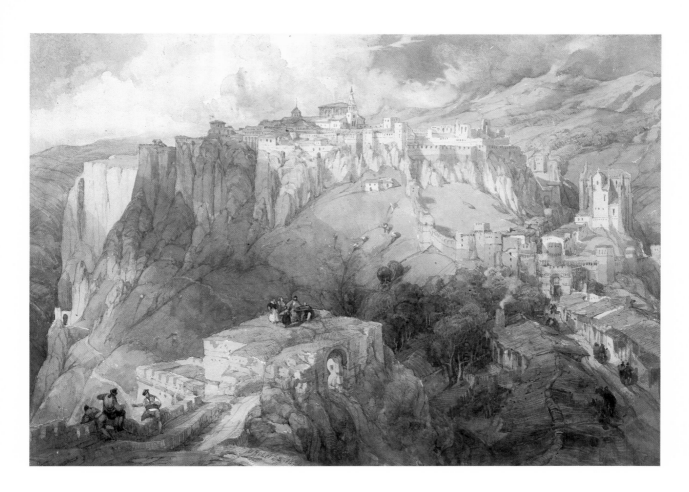

22 David Roberts
Ronda, Spain dated 1834
[TOIOII]

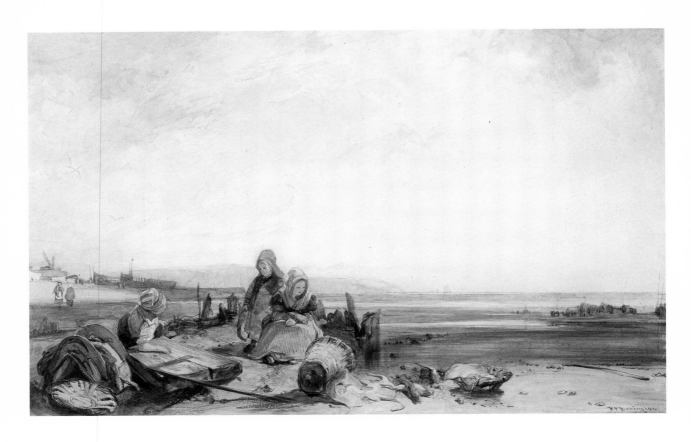

23 Richard Parkes Bonington
 Beach Scene on the French Coast
 Watercolour over pencil, 8⅜ × 13
 (213 × 242)
 [T03857]

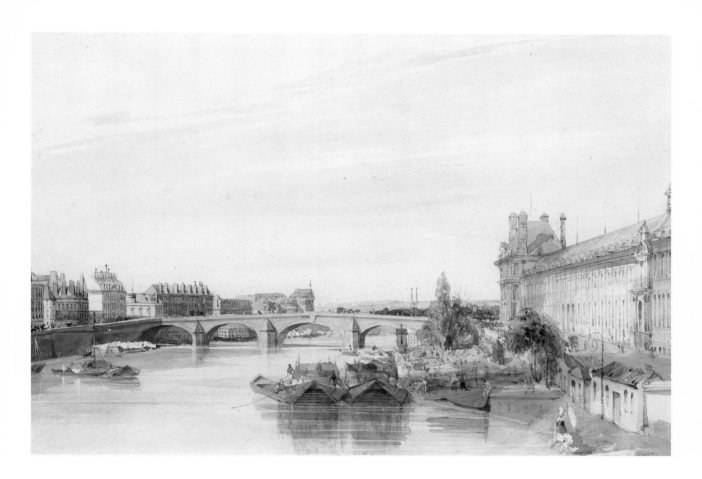

24 Thomas Shotter Boys
The Seine and Palace of the Tuileries
Watercolour, some highlights scratched out,
$7\frac{7}{8} \times 11\frac{5}{8}$ (200 × 295)
[T00966]

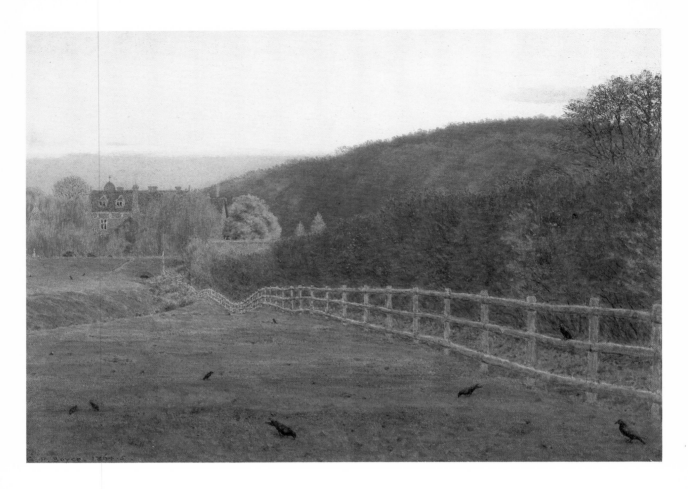

25 George Price Boyce
Landscape: Wootton, Autumn dated 1864–5
[N05250]

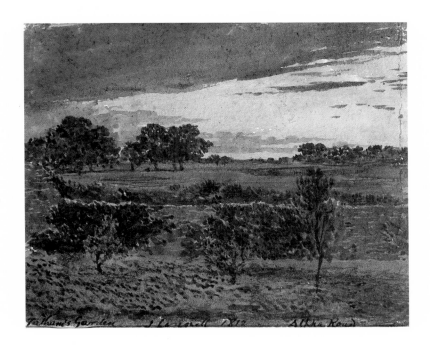

26 John Linnell
 Tatham's Garden, Alpha Road, at
 Evening dated 1812
 Watercolour, $4 \times 4\frac{7}{8}$ (102 × 125)
 [T04139]

27 Samuel Palmer
A Dream in the Apennine exhibited 1864
Watercolour and gouache, 26 × 40
(660 × 1016)
[N 05923]

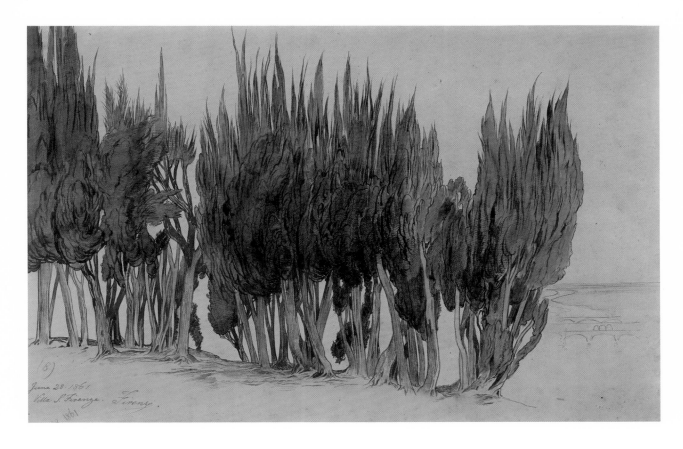

28 Edward Lear
Villa S. Firenze dated 1861
Watercolour, 9 × 13⅛ (229 × 352)
[N 02799]

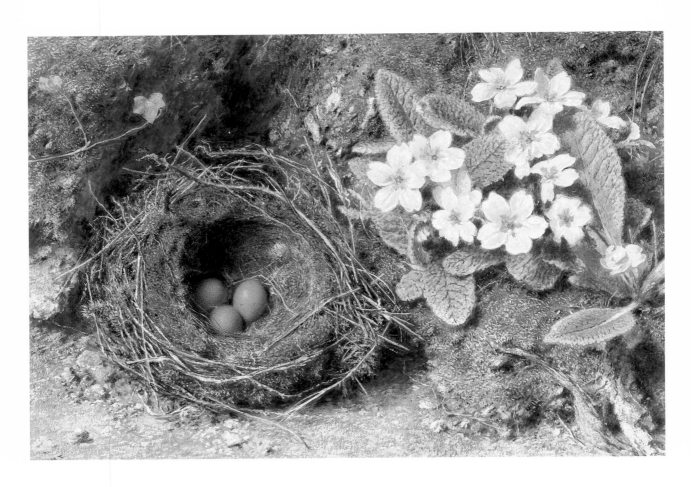

29 William Henry Hunt
Primroses and Bird's Nest c.1830
Watercolour and gouache, 7¼ × 10¾
(184 × 273)
[N 03564]

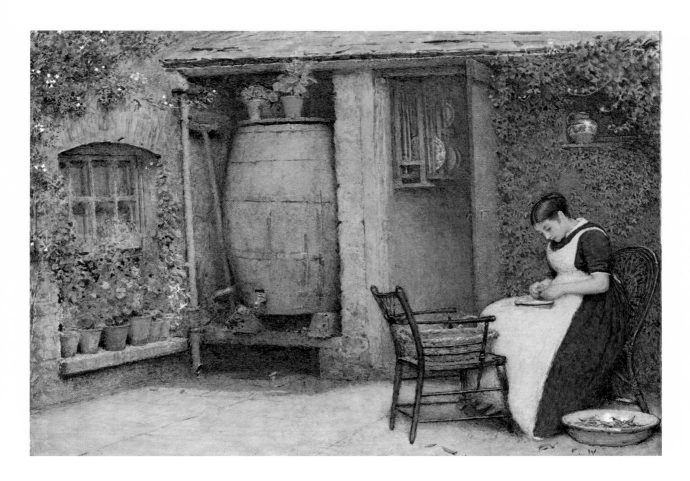

30 Frederick Walker
The Housewife painted in 1871
Watercolour and gouache, 7 × 10
(178 × 254)
[N 03526]

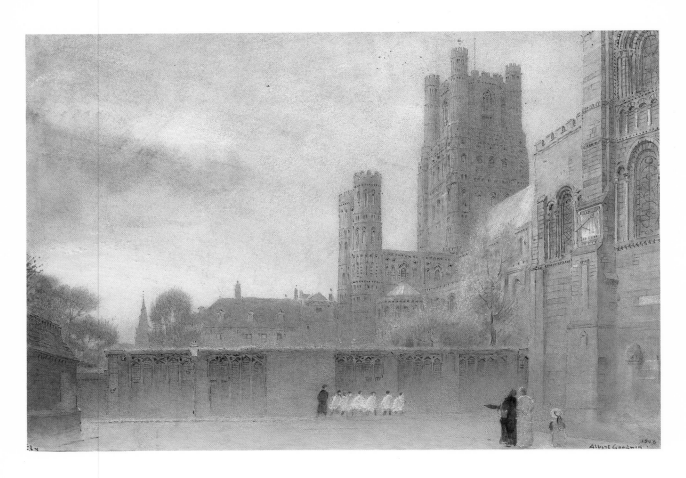

31　Albert Goodwin
　　Ely Cathedral　dated 1908
　　Watercolour, 10 × 14¾ (254 × 375)
　　[N 02299]